Calligraphy by
Arthur Baker

Dover Publications, Inc.
New York

PUBLISHER'S
NOTE

The present book, devoted to the art of a single outstanding exponent of calligraphy, is not burdened with basic exposition. Information on standard calligraphic technique can be found in many books. The following are particularly recommended:

Alfred Fairbank, *The Story of Handwriting*, Watson-Guptill, New York, 1970.

Edward Johnston, *Writing and Illuminating and Lettering*, Sir Isaac Pitman and Sons, London, 1906.

Tommy Thompson, *The Script Letter: Its Form, Construction and Application*, Dover, New York, 1965.

Published in Canada by General Publishing Company, Ltd., 30 Lesmill Road, Don Mills, Toronto, Ontario.

Published in the United Kingdom by Constable and Company, Ltd., 10 Orange Street, London WC 2.

Calligraphy by Arthur Baker is a new work, first published by Dover Publications, Inc., in 1973.

Library of Congress Catalog Card Number: 72-93759
International Standard Book Number: 0-486-22895-9

Manufactured in the United States of America
Dover Publications, Inc.
180 Varick Street
New York, N.Y. 10014

FOREWORD

Language becomes music through the flowing pen of Arthur Baker's calm and facile hand. His love of beauty is so unselfishly expressed in his work that one reads joy in each letter, in each word, in the rhythm of his designs.

He is a true child of the masters of his ancient and universal art of calligraphy. In his generation this student has no master and few peers. Arthur Baker weaves his script on a fanciful and magic loom from his personal and endless patterns. In other words, in just one word—in his art he's a natural.

His work in another sense spells pastime. Its disciplined freedom is distinctly his own. Beautiful writing is a universal hobby and one could become confused describing the calligraphy of one of Armenian ancestry who writes a beautiful Americanized Irish uncial Italian hand developed in of all places—California. There is nothing pretentious in his style. Perhaps the word should be mischievous, for it always defies the dullness of repetition.

The forms of our traditional alphabet are modified by the influence of the shape of the pen. Made with a flat pen, vertical strokes are naturally thick, while oblique or horizontal strokes are thin. Oval forms become tilted, as the flat edge of the pen is naturally held obliquely to the arm.

The letters are made between two imaginary lines, the height of the small letters. A third imaginary line establishes the height of capital letters and the ascending strokes of certain small letters. A fourth line, the descender line, marks the extent of strokes of some small letters.

Within a constant underlying pattern of rules our writing was systematically designed. It is divided into lines of sentences of separated words; punctuation points are used to indicate clauses. The first letter of each sentence is invariably capitalized. All else in the character of writing is personal styling. The best cursive writing today is little changed in basic style from the forms used to write the Charter of the City of London, or our Declaration of Independence.

The italic characters in all fonts of book type, used for emphasis, are the descendants of the humanistic cursive from which our types were fashioned. As all needless scrawls and flourishes obscure the clear readability of the letters, ornament is best used only in the short statement, particularly the title. The longer the text, the simpler and more legible should be the letter forms.

The letters themselves are more clearly identified with the weighting of the principal forms—the stems, and the bowls of the round forms. Thin lines serve to connect combinations of the forms which fashion the letters. It will be noted in comparing the pen-written cursives in this book to the plain everyday roman type used to print this foreword that the relationships are the same.

In this most beautiful calligraphy, rhythm, letter design and disciplined composition are accomplished without showing human effort. Character refinement in the person of the writer will always be evident in this expression of art and joy.

A life without beautiful writing would be as empty as one without reading. To attain a fine writing hand one must imitate to learn the way. As George Bickham stated it in 1741, "If you would write both Legible and Fair, Copy these Alphabets with all your Care."

TOMMY THOMPSON

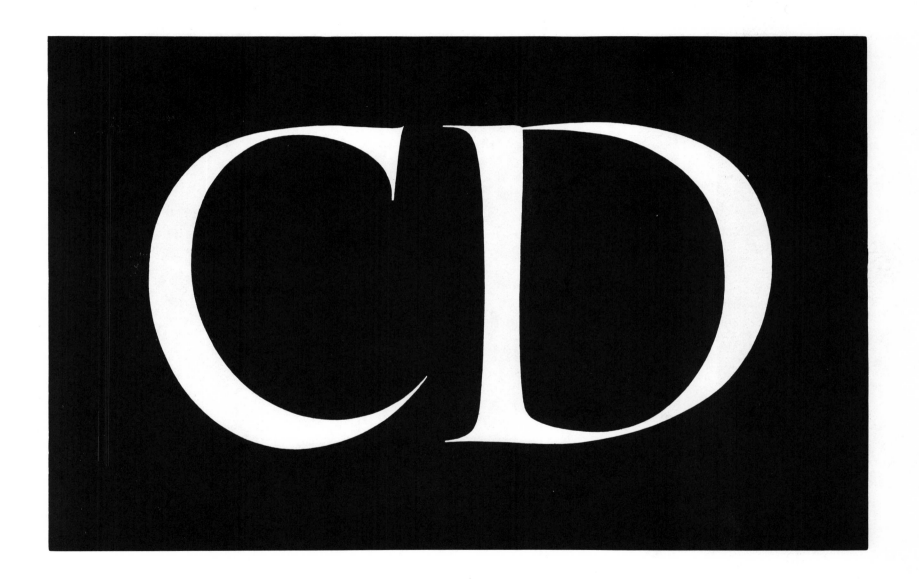

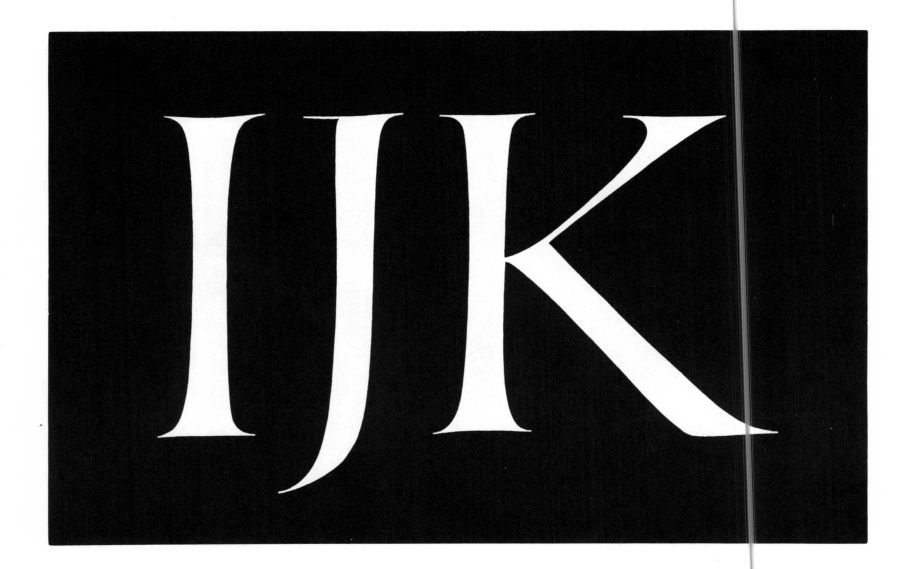

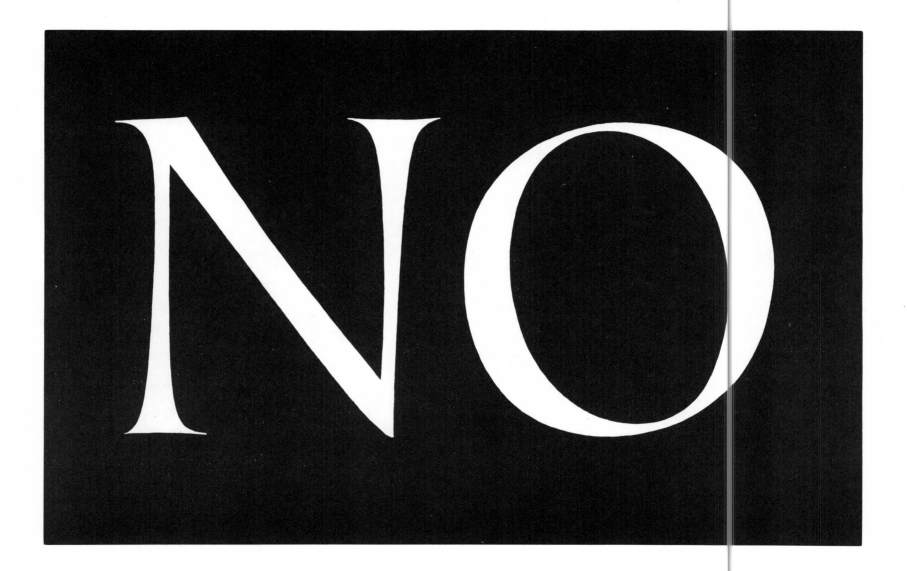

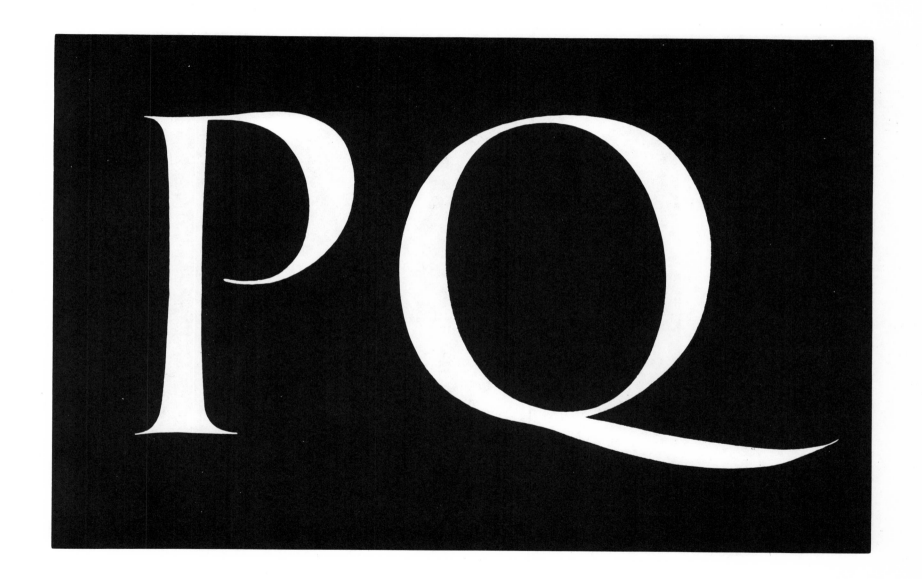

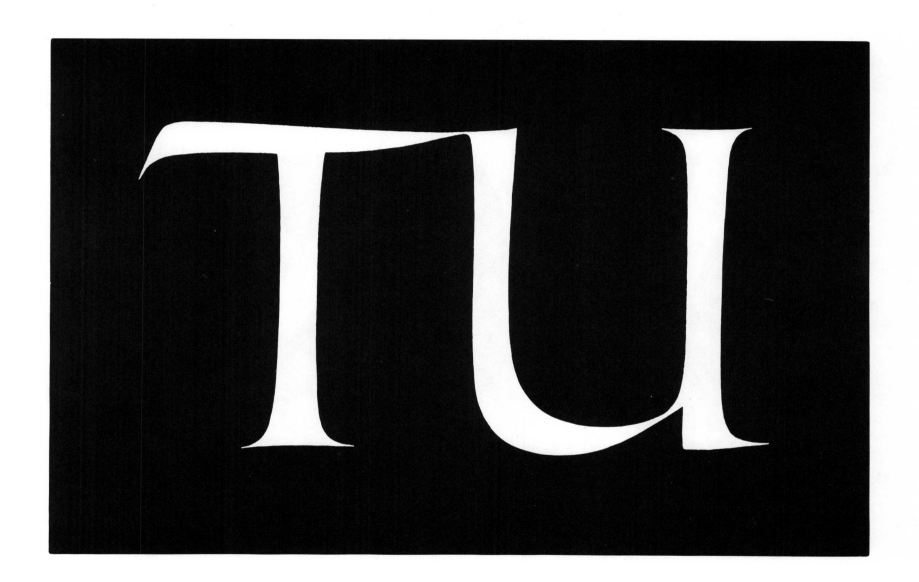

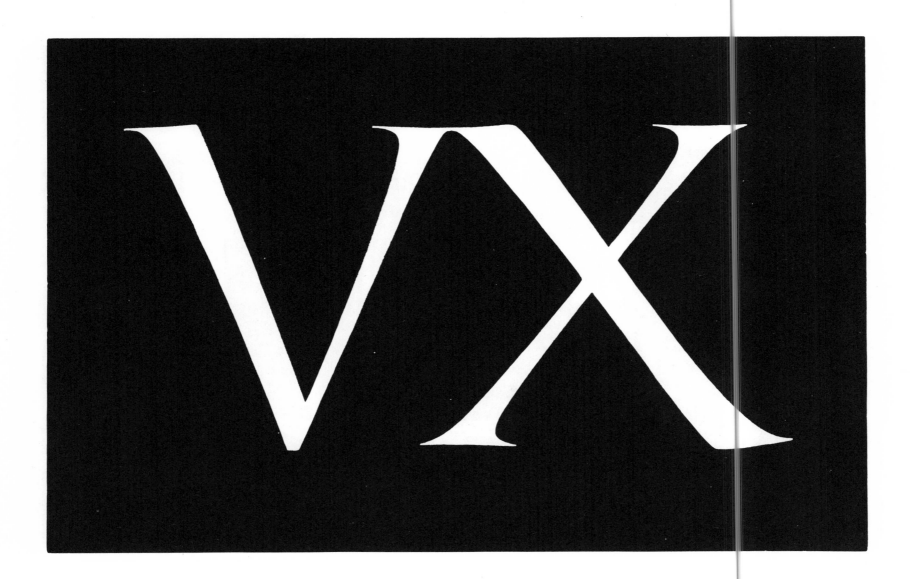

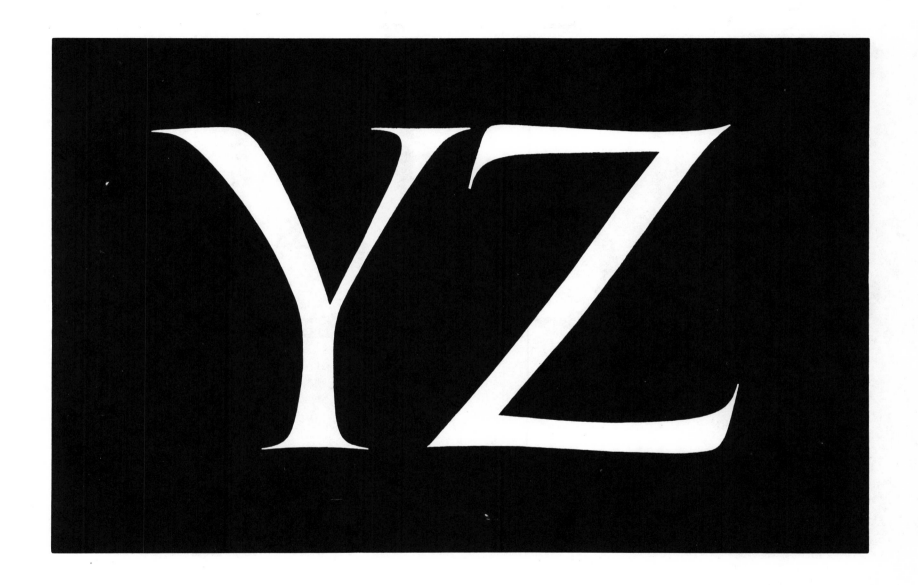

abcdefg

abcdefg

Aabcdeghijklmnopqrstuvxyz

Scribebat

Calligraphy

Aabcdefghijk

lmnopqrstuv

vwxyz

ABC abc
defghijklmnop

qrstuvwxyz

Scripta

Tekoa

abcdefghíjklmnop
qrstuvwxyz

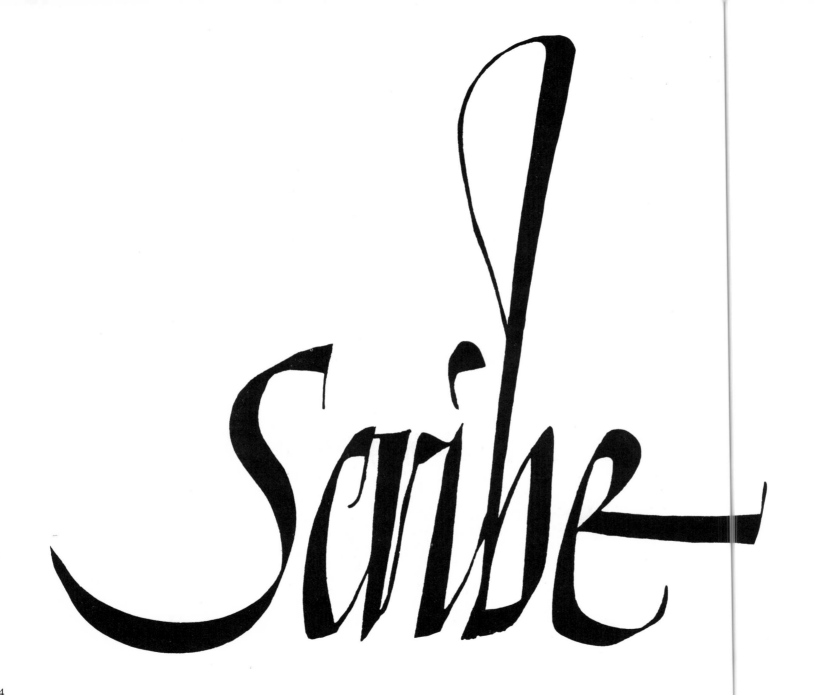

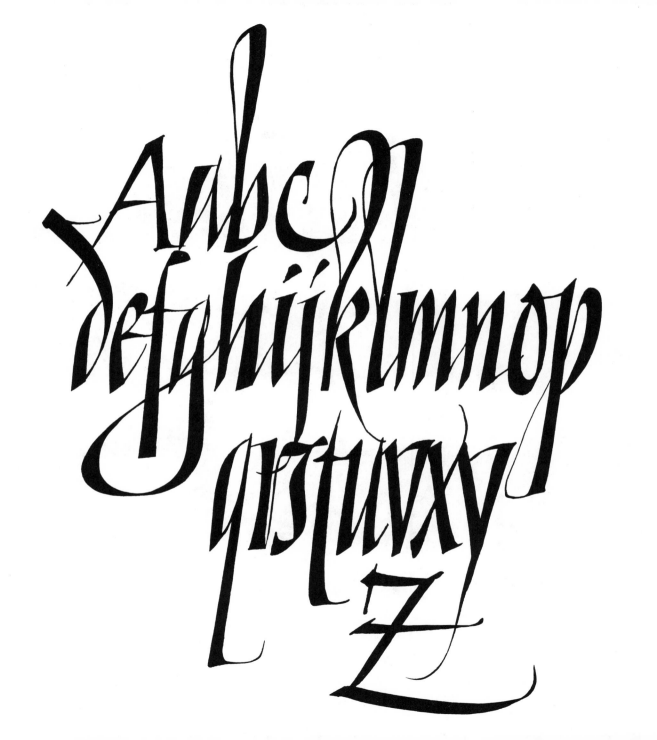

abcdefghijklmnop qrstuv wxyz

26

calligraphic

imponē
scribebat
abcdefghijk

Aabcdefghijklmnop

qrstuvwxyz

AabcdefghijklmnopqrstuvxyZ

30

Arthur Baker 1969

abcdefghijklmnopqr

stuvwxyz

aab

abcd

efghíj

klmn

opqr

stuvx

Aabcdefghijklmnopqrstuvwxyz

Thoughts are formed with words,
words, with letters
The melody of thoughts and words
resounds in the ornament of letters.

Alexei Remizov

Aabcdefghijklmnoporstuvwxyz

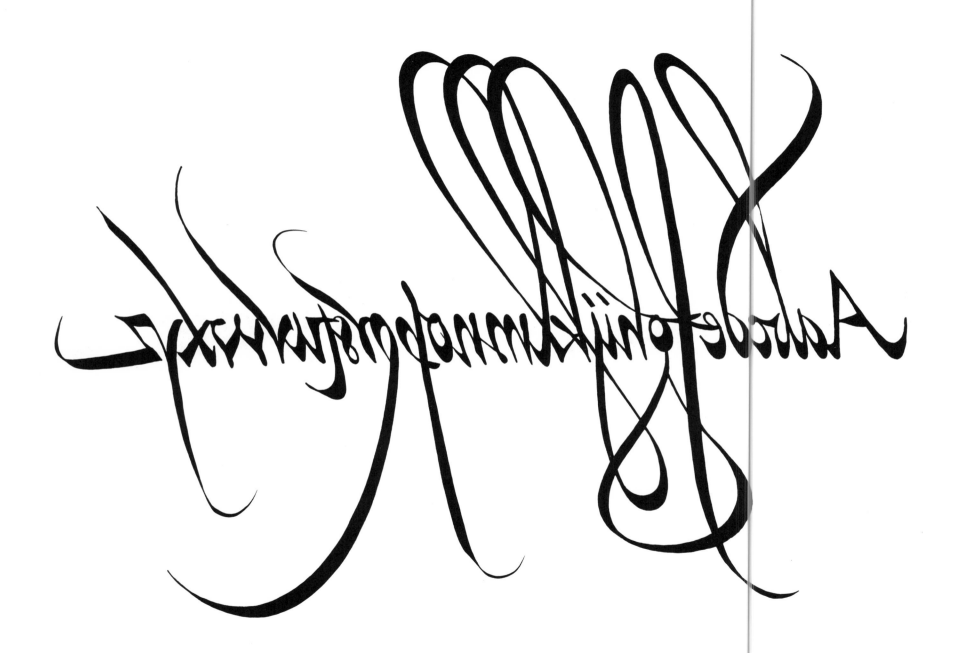

44

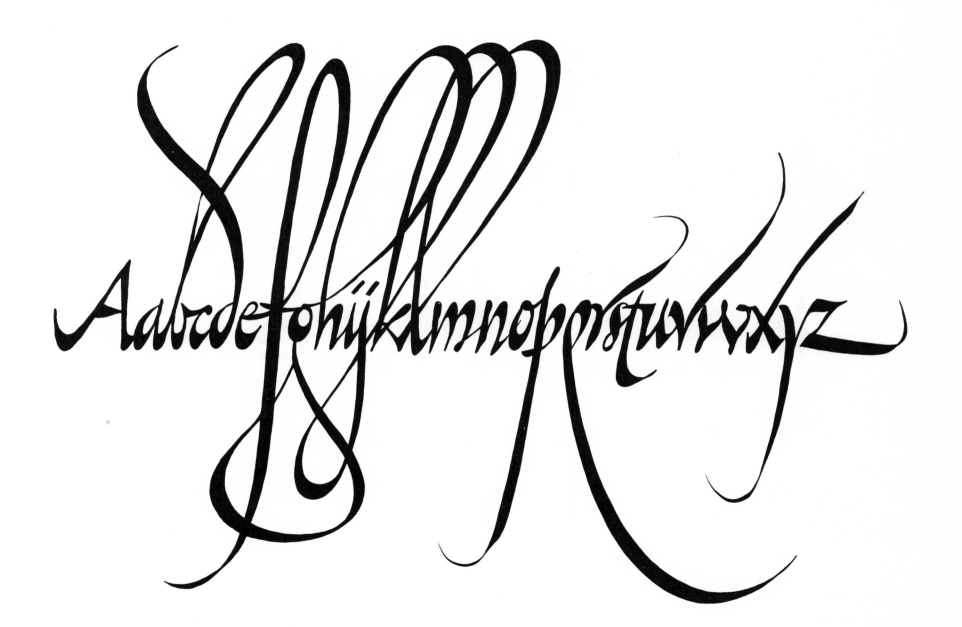

Aabcdefghijklmnopqrstuvwxyz

Aabcdefghijklmnopqrstuvwxyz

Calligraphy abcdefghijklmn

Calligraphy

What God hath joined together,
let no man put asunder.
abcdefgghijklmnopqrstuvxyz

hieroglyphica

Aabcdefghïjklmnopqrstuvwxyz

51

lettera
scripta

Aabcde
fghijk
lmn
opqrstu
vwxy
z

Aabcdefghÿklm

klmnoporstuvwxyz

Great peace have they that love

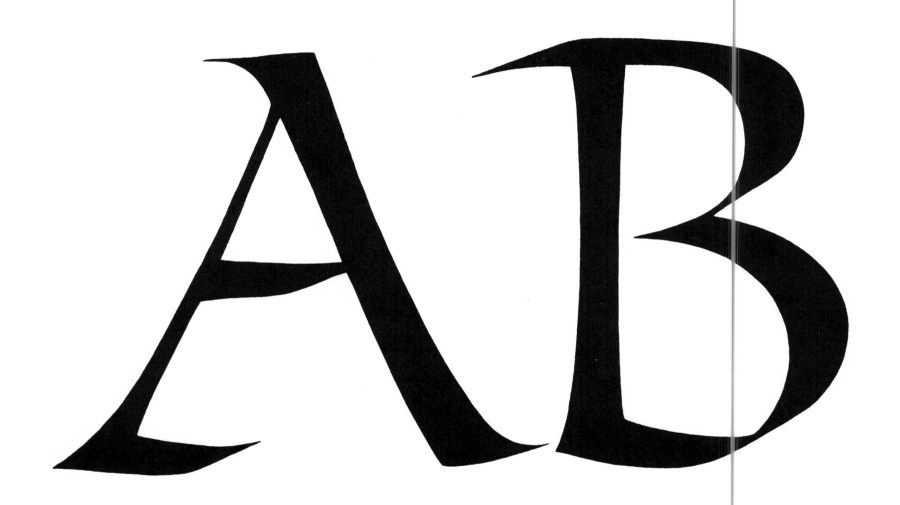

AB

Alphabet

abcdefghijklmn
opqrstuv
xyz

abcdefg

abcdefg

Paleography & calligraphy

Aabcdefghijklmnoporstuvwxyz

Aabcdefghijklmn

hijklmnopqrstuvwxyz

Calligraphic

Abcdefghijkl
mnopqrs tuvw
xyz

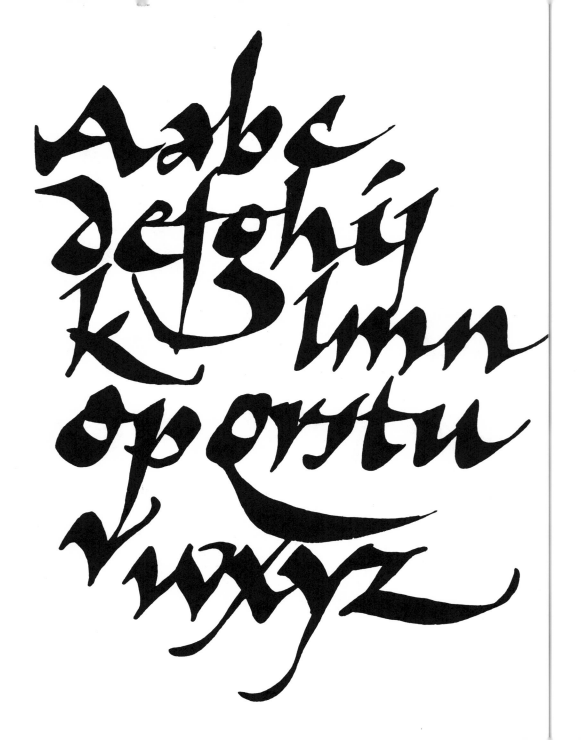

Great
peace
have they
that love

Alphabet

abcdefghi

Scribebat
Aabcdefghijk
lmnopqrstuv
wxyz

Calligraphic

The quick brown fox jumps over lazy dog.

The quick brown fox jumps over lazy dog.

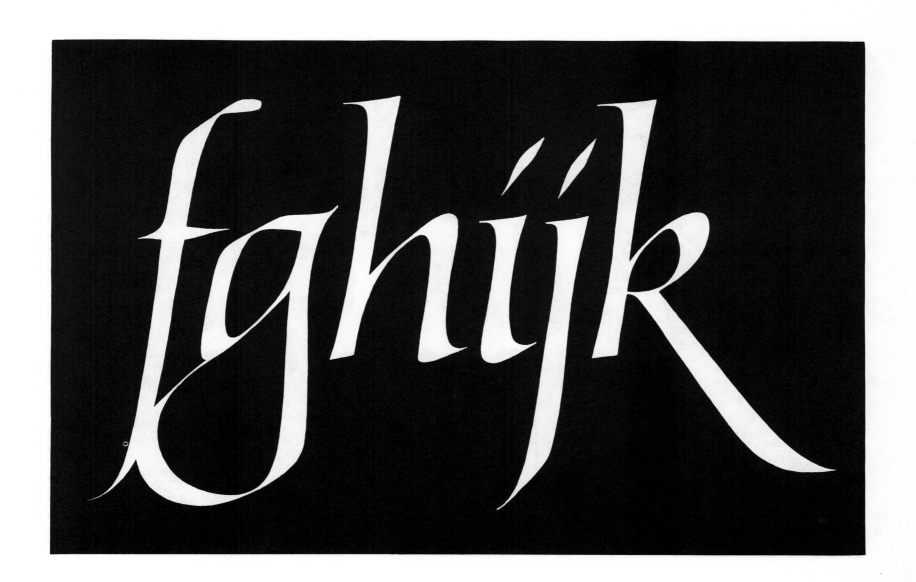

lmnop

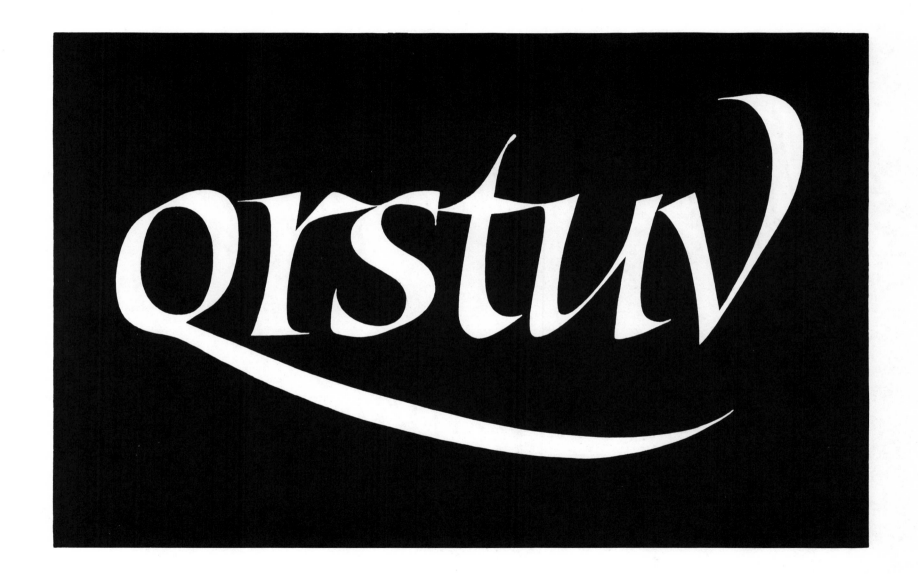

Aabcdefghijklmnopqrstuvwxyz

calligraphic

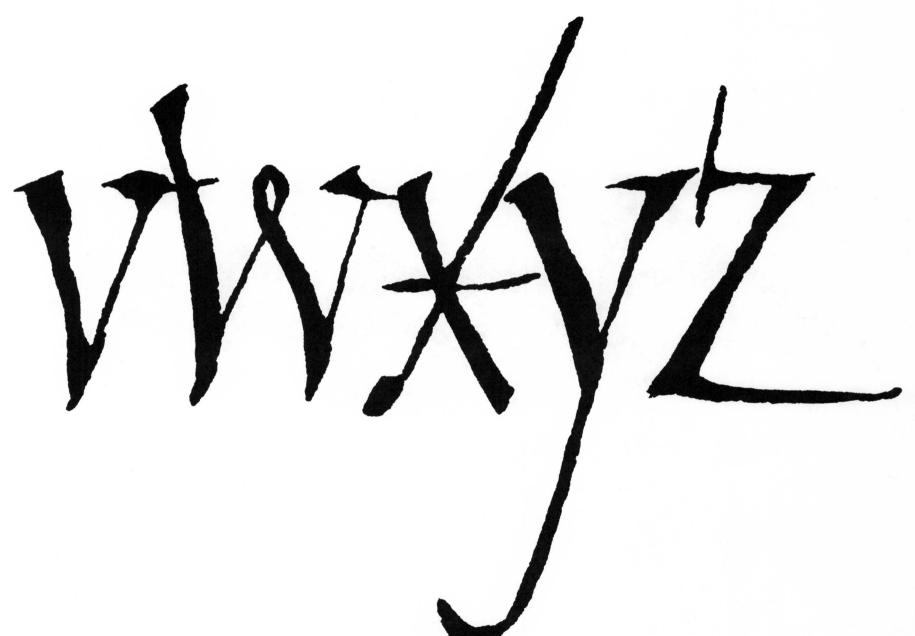

Aaaaabcdefghijklmnop

orstuvwxyz

AabcdefghijklmnopqrstuvxyZ

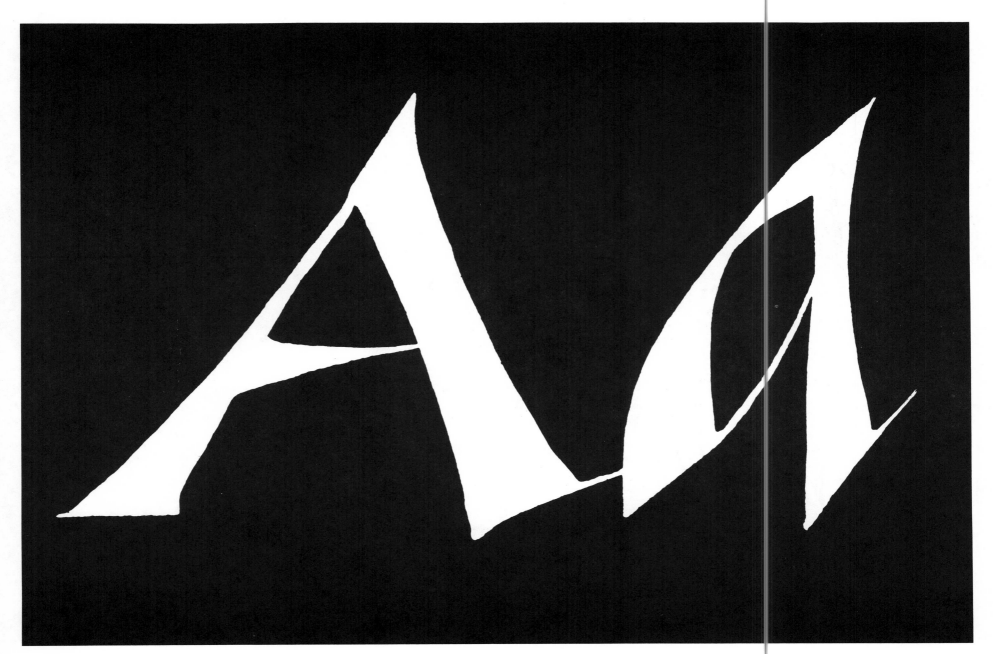

Aabcdefghijk
lmnopœorstu
vwxyz

NopQRS

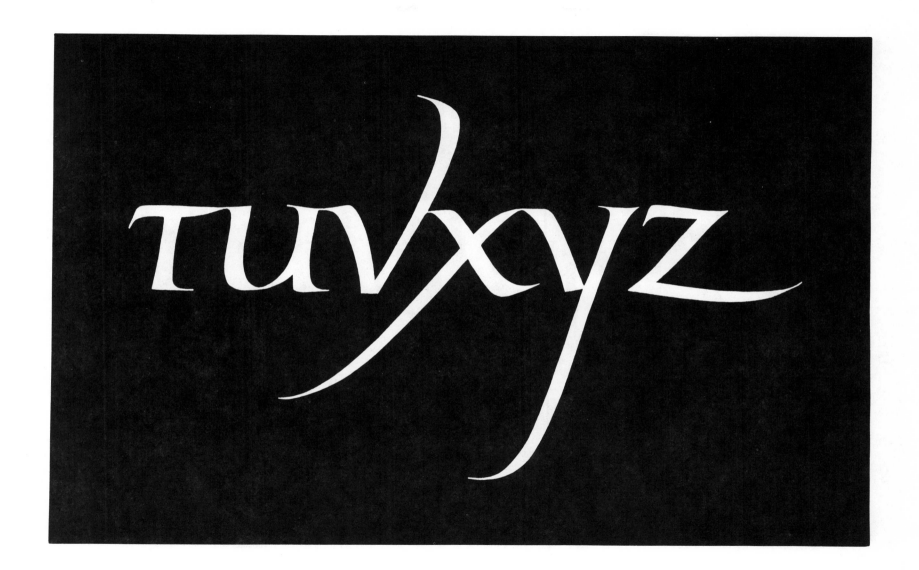

Mardersteig

Aabcdefghijklmnopqrstuvxyz

ABC

ABCDEFGHIK
LMNOPQRS
TUVXYZ

the quick
brown fox jumps
over the lazy
dog

Aabcdefghijklmnop
qrstuvwxyz

calligraphy

abcdefghijklmnopqrstuvxyz

abcdefghijk

Aabcdefghijklmn
nopqrstuvwxyz

abcdefghijklmn
opqrstuvwxyz

cheltenham

abcdefghijklmnop

qrstuvwxyz

quincy

Aabcdefghijklmnopqrstuvwxyz

Calligraphy

California

abcdefghîjklm
nopqrstuvwxyz

Aabcdefghijklmnopqrs
stuvwxyz

Woe unto you, when all men speak well of you.

abcdefgh

Scripta

Aabcdefghijklmno
pqrstuvwxyz

Great peace have they
that love Thy Law
and nothing shall
offend them.

Calligraphy

Aabcdefghijklmnopqrstuvxyz

Alphabet Calligraphy

Aabcdefghijklmn

Aabcdefghijklmnoporstuvwxyz

Handwritten

calligraphy

abcdefghijklmnopqrstuv

wxyz

calligraphy

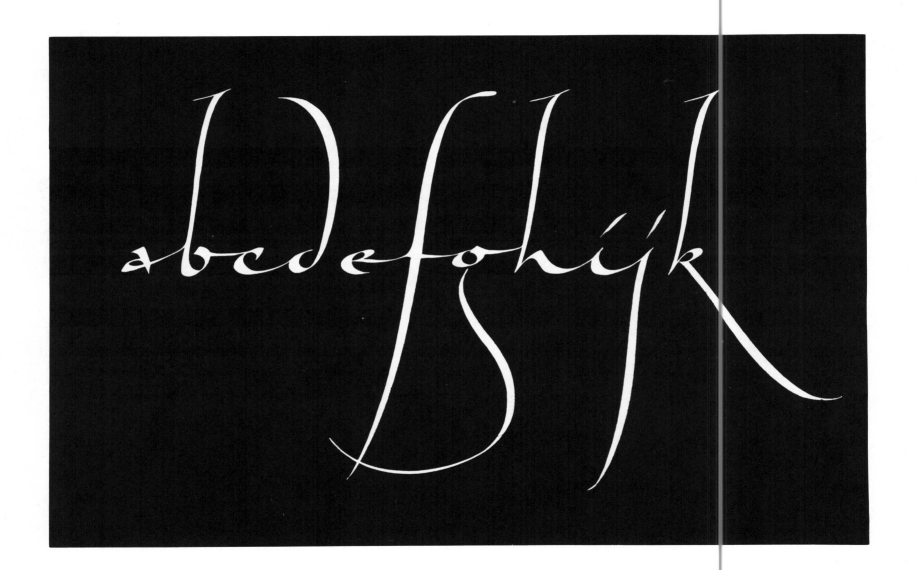

lmnoporstuv

calligraphy

abcdefghij

Aabcdefg
hijklmno
pqrstuvx
wxyz

abcdefghijklm
nopqrstuvwxyz

calligraphy

abcdefghijklmnoprstuvwxyz

calligraphy scribendo

Maximilian

Sabrina

Aabcdefghijklmnopqrstuvwxyz

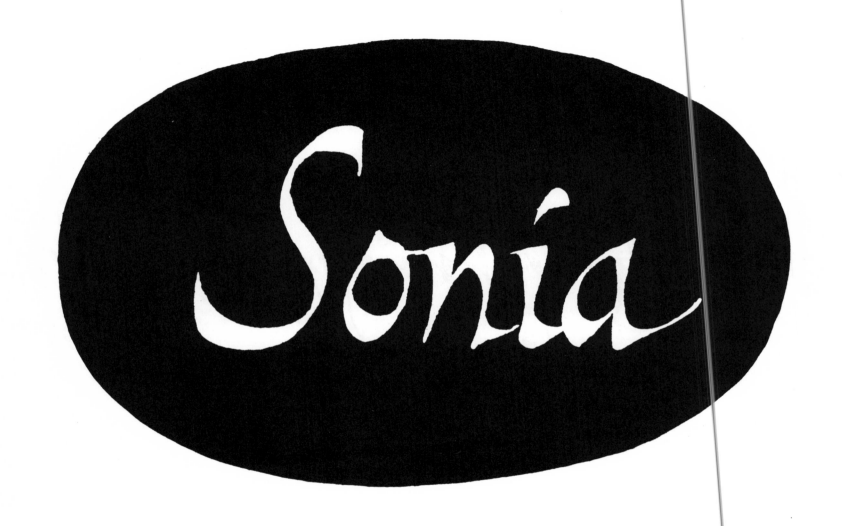

AabcdefghijklmnoP

qrstuvxyz

135

scribendi
abcdefghijk
lmnopqrstu

abcdefghijklmnop
qrstuvwxyz

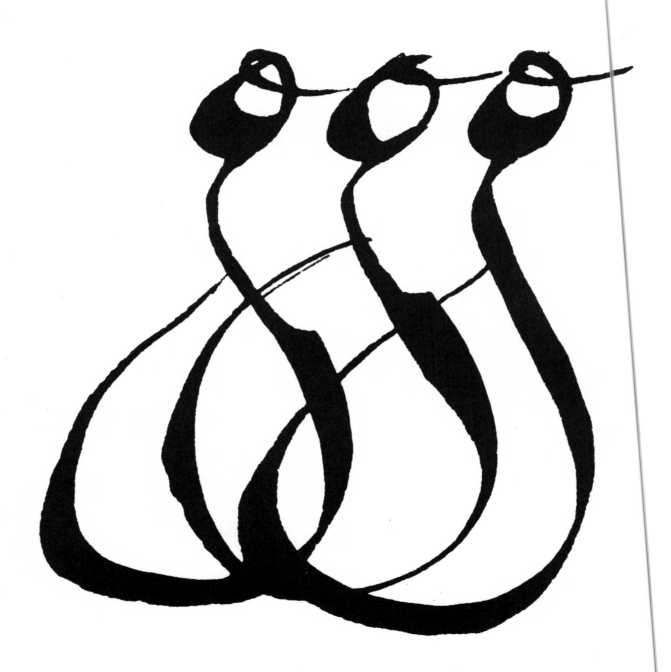

Aabcdefghijklmnopqrstuv

wxyz graphic ggorabcd

Calligraphic

Aabcdefghijklmnop
qrstuv xyz

Hear this word that the
Lord hath spoken
against you, O children
of Israel,

Aabcdefghijklmnop
qrstuvwxyz

Calligraphy

abcdefghijklm

Calligraphic

abcdefghijklmn
opqrstuvwxyz

Amos

Scribebat

Aabcdefghijklmnopqrstuvxyz

Blessed
are
the
peace
makers

A abc
de fghijk
lmnop
qrst uvw
xyz

Jehovah Lord,
Make room for rest, round me!

Elizabeth Browning

Aabcdefghijklmnopqrstuvwxyz

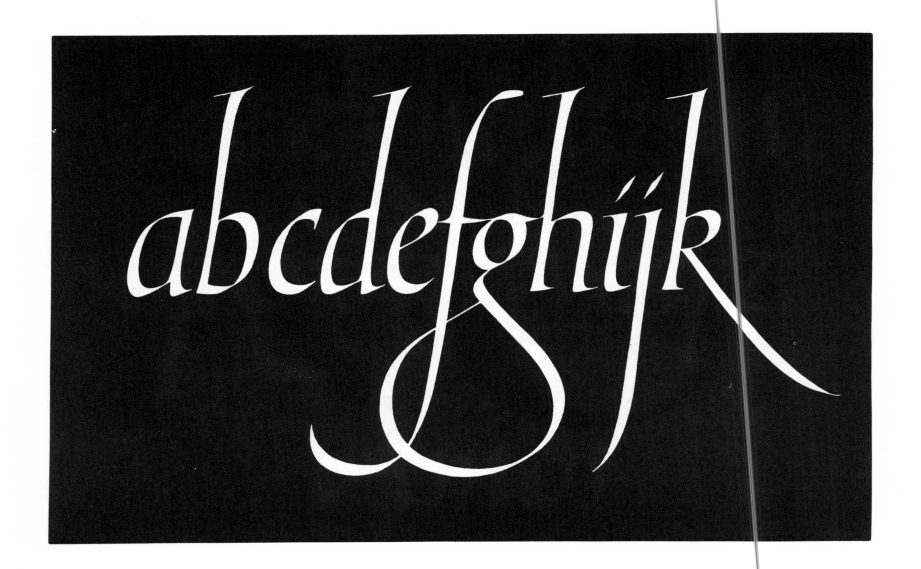

152

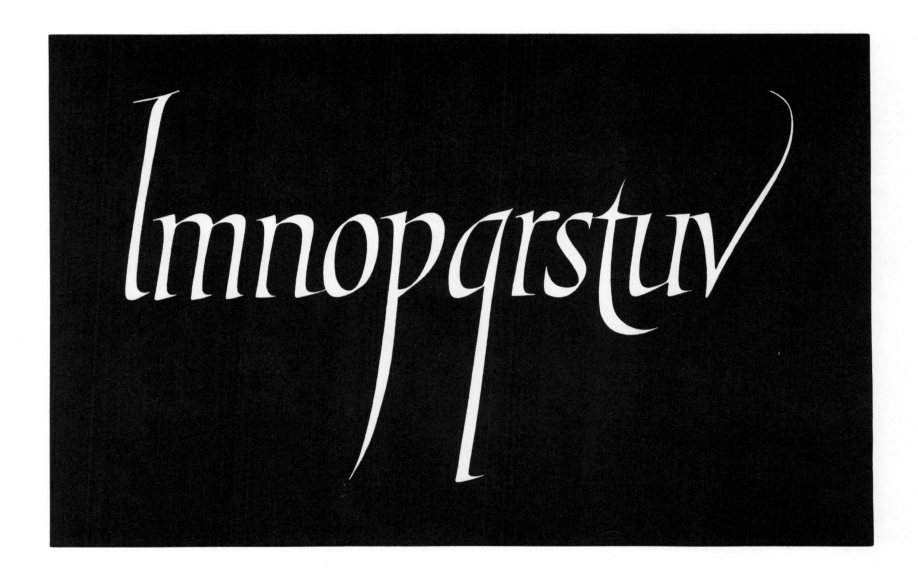

153

Aabcdefghijklmnopqrstuvwxyz

Thoughts are formed with words

Arthur Baker